Celtic Fantasy in Watercolour

STUART LITTLEJOHN

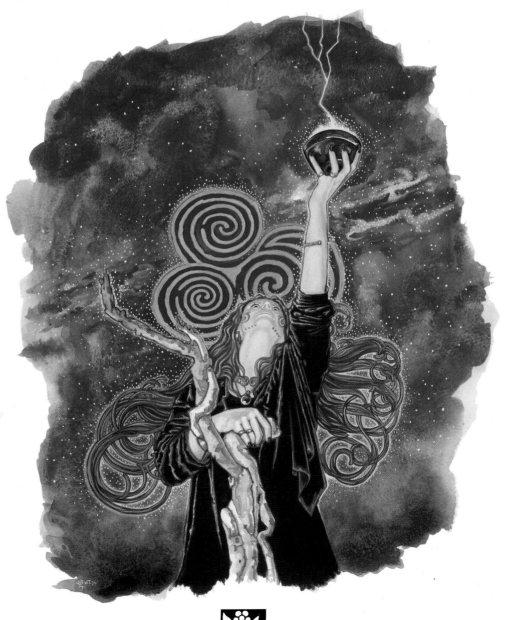

SEARCH PRESS

First published in Great Britain 2008

Search Press Limited
Wellwood, North Farm Road,
Tunbridge Wells, Kent TN2 3DR

Text copyright © Stuart Littlejohn 2008

Photographs by Steve Crispe at Search Press Studio, and
Roddy Paine Photographic Studio

Photographs and design copyright © Search Press Ltd. 2008

ISBN-13: 978-1-84448-292-4

The Publishers and author can accept no responsibility for
any consequences arising from the information, advice or
instructions given in this publication.

The Publishers would like to thank Winsor & Newton for
supplying some of the materials used in this book.

Suppliers
If you have difficulty in obtaining any of the materials or
equipment mentioned in this book, then please visit the Search
Press website for details of suppliers: www.searchpress.com

Publishers' note
All the step-by-step photographs in this book feature the
author, Stuart Littlejohn, demonstrating his watercolour
painting techniques. No models have been used.

There are references to animal hair brushes in this book. It
is the Publishers' custom to recommend synthetic materials
as substitutes for animal products wherever possible. There
is now a large range of brushes available made from artificial
fibres, and they are satisfactory substitutes for those made
from natural fibres.

Acknowledgements

*My thanks go to Roz, Katie, Juan and all at Search
Press for their help, enthusiasm, encouragement
and vision. It is always good to make new friends,
as well as meeting up with old ones.*

*To Ali, for her constant support; I could not have
completed this without her. To Puck and Shovel,
for walking over various bits of artwork at very
delicate moments. To the Star, Sunflower, She of the
Sorrows and the Grey Mare, Muses all. And finally
to all the friends and companions along the road
who have put up with the inevitable artistic hissy
fits and tantrums.*

*Last and not least, to Trixybelle and TickyWoo
– they know who they are!*

Dedication

*This book is dedicated to my daughters
Annie, Saskia, Aoife and Jasmine. xxxx*

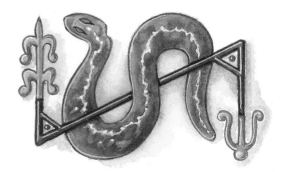

Cover:
The Guardian
*Embodying the sacred guardianship of the land, personifications
of the goddesses, the warrior queens of Celtic times, were forces
to be reckoned with. Historically, Boudicca and Cartimandua,
along with Maeve and Morgan le Fay from legend, are some
whose images and stories are still remembered.*

Page 1:
Druidess
*Drawing on the power of the elements, the Druidess guides the
fortunes of the tribe.*

Opposite:
The Washer at the Ford
*Seen as an aspect of Morrigan, any warrior encountering the
silent woman washing blood-soaked garments at a ford, knew
they were about to fall in the coming battle.*

Contents

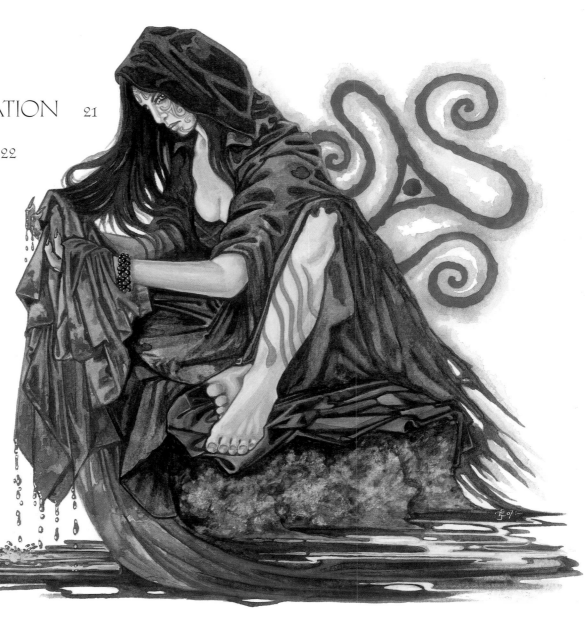

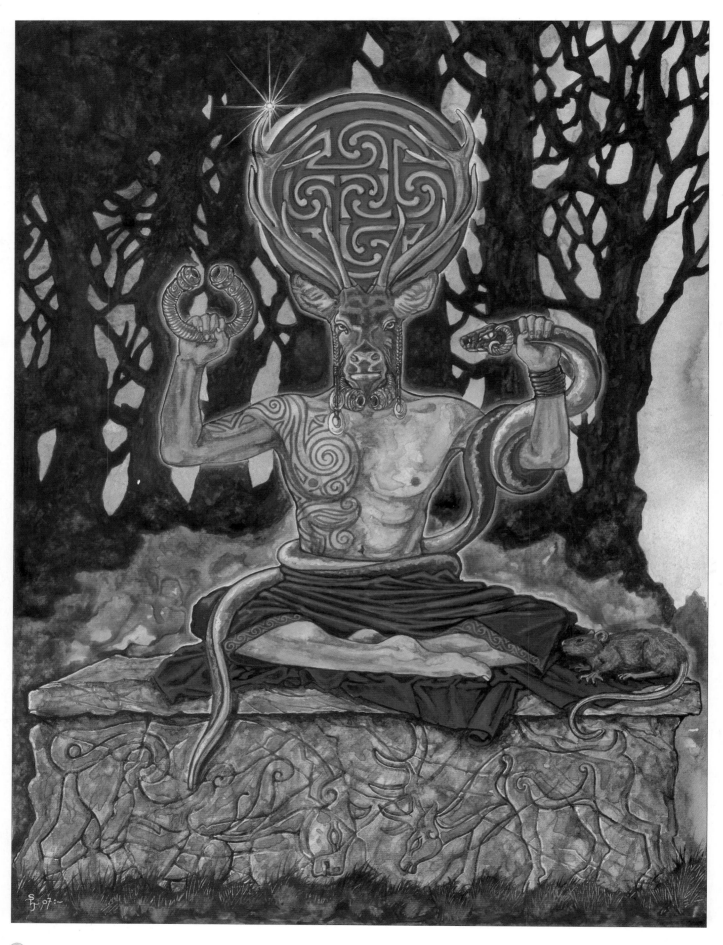

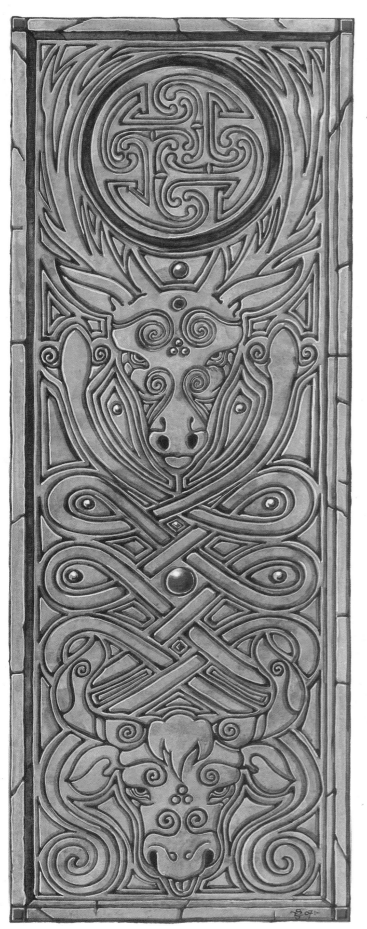

Introduction

The subject of Celtic art, mythology and fantasy is vast, with as many intertwinings and transformations as the most complicated piece of knotwork. Knowing where to begin, finding the end of the strand, can be highly confusing, but if you feel the pull of Celtic stories, from the myths of Ireland to the great Arthurian legends, and you want to attempt to illustrate them, then hopefully this book will give you a jumping-off point, a few guidelines to techniques, and shortcuts that will get you weaving your own kind of visual magic.

The most important point is to have fun and enjoy the process, and do not worry about making mistakes. As my Kendo Sensei always says, 'You never learn anything by winning constantly'.

Feel free to build on anything you find here. If a technique I describe does not work for you, adapt it and experiment; this book is not a set of rules carved in stone.

You have no limitations and can travel wherever your imagination takes you. Gather inspiration from whatever is at hand: on walks or holidays; from books, television, films or the Internet. Carry your sketchpad, pencil and trusty digital camera wherever you go. Collect interesting objects, stones, shells, feathers, whatever catches your eye. Very soon you will have your own library of reference material. And do not forget to look at other artists' work to see what has influenced them.

Hopefully this book will open a door for you, and you will learn something new and have fun with your painting. As you gain experience and confidence, allow the magic of the Celts to grow strong in you – draw on its power to guide and inspire you, and you will find a rich source of pleasure and creativity.

Cernunnos

The great Antler-horned god of Celtic myth is shown on page 4 with his symbolic animals: the bull, deer, horned serpent and rat. He holds a golden torc that declares his status. Cernunnos is the god of fertility and wealth; the serpent and rat link him with the Otherworld and the powers of death and rebirth.

Materials

Art materials can be very expensive and it is certainly a case of 'you get what you pay for'. There is a huge choice of paints, brushes and paper on the market, not to mention all the sundry extras like craft knives, burnishers, erasers, drawing boards, etc. It can be very confusing when you begin to gather the materials that you need together. It is best not to dive in and go wild; just concentrate on the basics to begin with: half a dozen good quality brushes of various sizes, a pad of mediumweight watercolour paper, a dozen or so tubes of watercolour paint and a selection of pencils of differing hardness should be enough to get started with.

BRUSHES

Buying brushes is possibly the most difficult part of any project. Not only do they come in a bewildering choice of sizes and types, but you also have to negotiate the very attractive selection of handle colours, which if you are not careful can drag you away from what you are really looking for! If you manage to avoid that particular temptation then you have to choose between sable, synthetic or a mix of both, as well as differing sizes, from what appears to be a single hair to the equivalent of a wallpaper brush. Again, it is a case of getting what you pay for.

I would recommend pure sable brushes, but they are expensive. Synthetic brushes are probably the best to begin with; you will find with practice which kind of brush suits your way of working.

I use a mix of sizes, from Nos 00 to 4 for detailed work, up to Nos 7 or 8, or a 13mm flat brush, for larger areas and backgrounds.

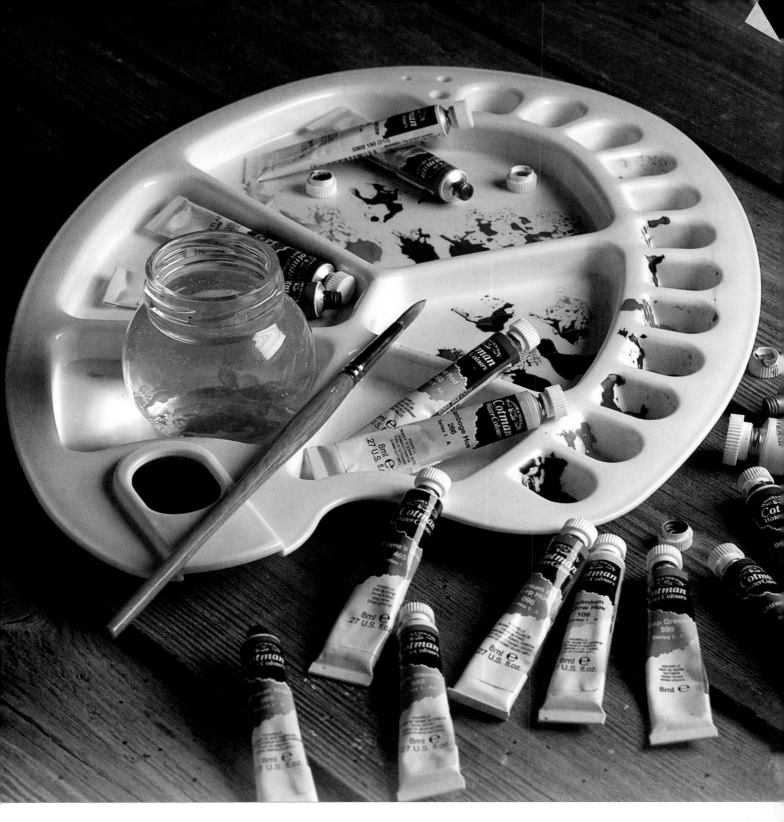

PAINTS

There is a vast range of watercolour paints available, from the very cheap to the extremely expensive artists' blocks of the finest pigments. I mainly use tubes, which I find very convenient, and the choice of colours is wide. To begin with, aim for about a dozen colours that cover the spectrum. Include in this the primaries (red, yellow and blue) as well as some white gouache. Gouache is more opaque than watercolour and is ideal for highlights in your paintings.

My palette, together with a range of the watercolour paints I used to produce the paintings for this book. Your palette can be an elaborate ceramic mixing dish or else a much cheaper plastic version. If all else fails, a plain white plate or saucer works just as well. Similarly, you can buy water pots especially made for artists, but a jam jar is ideal. I use a small glass jar with a round bottom that originally held wholegrain mustard.

PAPER

The type of surface that you paint on has important effects on the finished piece. Watercolour papers range from very smooth (often described as HP, or hot pressed) to rough and heavily textured (described as NOT or cold pressed). Throughout this book I have used 300gsm (140lb) cold pressed NOT papers.

Alternatively, experiment with the surfaces you paint on. Wood and medium-density fibreboard (MDF) can give a wonderfully hard, smooth finish. First find a piece that is a suitable size, then sand it down and prime it with white matt emulsion paint. You will need at least a couple of coats, each sanded down when dry using fine-grade sandpaper to get rid of any imperfections. The brilliant white primer will give an added lustre to your completed painting. Using off-cuts of wood or board, finished in the same way, is also a cost-effective method of trying out new techniques before moving on to the more precious watercolour paper.

When I use paper, I always stretch it before I start. This keeps the paper taut and stops it cockling when water is applied. To stretch paper you will need a wooden board (I use an A2-sized piece of thick marine ply), your sheet of paper and some brown paper sealing tape (this has water-soluble gum on one side). Soak your paper liberally on both sides with water and, using a sponge or cloth, dribble water on to your board underneath where you want your paper to sit. Lay the paper on to the board and gently expel any air bubbles from beneath the sheet; do not press or scrub the paper too hard as the surface might get damaged. When the paper is flat, tear off a strip of the sealing tape (a little longer than the longest side of your paper sheet), wet the tape with the sponge and stick it firmly along the edge of the paper and down on to the board. Try to ensure the tape is well stuck and repeat on the other three sides of the sheet.

When you have finished, let the paper dry naturally. Do not be tempted to hurry it along with a hairdryer, as it might pull off the board and you will have to start again. At this point you might be alarmed to see your beautiful sheet of paper begin to acquire ridges and bubbles, but do not worry – as it dries it shrinks and the whole thing should be pulled wonderfully taut, ready to paint on. This technique might take a bit of practice, but persevere, as it is worth it.

A selection of watercolour papers, including a sketchpad, which is useful for sketching out initial ideas and noting down anything that inspires you, and tracing paper for transferring designs on to watercolour paper.

You will need a board of some kind on which to rest your paper as you work – either a professional drawing board like the one shown here, or a piece of MDF.

OTHER MATERIALS

A good selection of pencils is essential. You will need at least a hard (H), medium (HB) and a soft (B). For very fine drawing, a 2H or even a 3H is advisable. This is particularly important when you come to paint over your underlying drawing, as the harder the line, the less likely it is to smudge when you apply the paint, and your colours will stay cleaner. For scribbling over the back of a tracing before transferring the image to paper, you will need an F pencil, which is between an H and an HB. Keep your pencils well sharpened with a scalpel, craft knife or normal pencil sharpener.

You will need an eraser for rubbing out pencil marks – a soft putty eraser is ideal as it can be shaped to a fine point if needed. Failing that, adhesive putty also works very well.

Use masking tape to secure your tracings to your board or paper, and brown paper sealing tape to attach your paper to your board when stretching it. Masking fluid, applied with an old paintbrush, can be used to mask out parts of your picture when you are applying washes. Kitchen paper is used for roughly masking out areas when you use the spattering technique, and also for lifting out paint or excess water from your work.

For drawing circles use a pair of compasses – ideal when positioning spirals or other circular pieces of decoration. An old toothbrush is the perfect tool for spattering fine drops of paint for sea spray or mist.

A hairdryer speeds up the drying process. By force-drying the paint, you can achieve some interesting effects as the warm air pushes the paint around on the paper.

Colour

There is an amazing range of watercolour pigments available, and it can be very confusing when first presented with the choice on offer. It is comforting to know that you can mix practically any colour you want from the three primary colours of red, yellow and blue; add white to lighten or blue/black to darken. It is always good to experiment with mixing, and do not be afraid to make mistakes. However, it can be a long process, and there is nothing worse than creating the most wonderful shade for a sky and then running out halfway through your wash and being unable to match the colour exactly when you mix another batch.

raw sienna
A good medium tone for hair or as the base colour for golden jewellery.

Hooker's green
A rich green, ideal for cloaks and foliage.

alizarin crimson
Slightly blue/purple red. Ideal for clothing and details like lips, especially when mixed with cadmium red.

sepia
Good for outlining and for deep shadows.

gamboge hue
A strong lemon yellow, perfect for giving an extra bright glint to gold or fire.

cobalt blue
An intense blue that works well with French ultramarine, especially in skies or water.

cadmium red deep
A strong, vibrant red when used alone; perfect for lighter areas on clothing or decoration.

Payne's gray
A neutral tone that is ideal for shadows or outlining. Use instead of black, which can become very dull.

Colour can also be mixed on the paper as you paint. This can lead to wonderful effects as one colour bleeds into the next. The best way to explore this is by creating test pieces, seeing which combinations of colour work well together and basically playing with the paint.

The selection of colours shown here should be enough to set you on your path, though you can expand your choice with any number of variations of green, blue, yellow and red when you have gained more confidence.

I must mention gouache, which is a thicker, opaque watercolour similar to poster paint. I use permanent white and very occasionally lamp black. Permanent white is perfect for putting in very bright highlights on clothing, in eyes and on jewels, painting starbursts and stars, or for spattering spray and mist. Its opacity means that underlying colour will not bleed through, making it ideal for hiding any mistakes.

cadmium yellow

A vibrant yellow that can be used straight from the tube for sunbursts or mixed with various reds for glorious sunsets.

French ultramarine

A bright, intense blue which I mainly use as a backdrop for star-strewn night skies – very dramatic.

burnt sienna

A beautiful orangey red/ brown, perfect for hair and general shading.

lamp black

Use only if absolutely necessary for very deep shadows, but try to add blue or brown to it to give it more depth and vibrancy.

sap green

A bright, vibrant green that is perfect for grass, especially when mixed with Hooker's

indigo

Indigo is ideal for shadows and darker shading on clothing. Works well with red

burnt umber

This is a good colour for shading on faces and hands. Mix it with raw sienna to lighten the tone. It can also be used on tree bark and rocks.

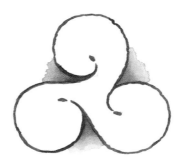

Chinese white

Use sparingly to lighten any colour or to soften areas, especially skin tones. Chinese white is very transparent so do not expect it to cover over any mistakes you might make.

Drawing figures

Drawing the human figure is possibly the most daunting task that faces anyone who begins to paint. It is highly unlikely that you will have a professional model that you can call upon, so you will have to make use of partners, friends, children and sundry pets. Using a digital camera is an instant way of seeing if you have achieved the pose you want. Other sources of reference for figures are magazines and the Internet. It is a good idea to start a scrapbook and collect any kind of picture that takes your fancy; you never know when and in what form inspiration might strike you. If you are drawing from scratch, the steps on the facing page may help.

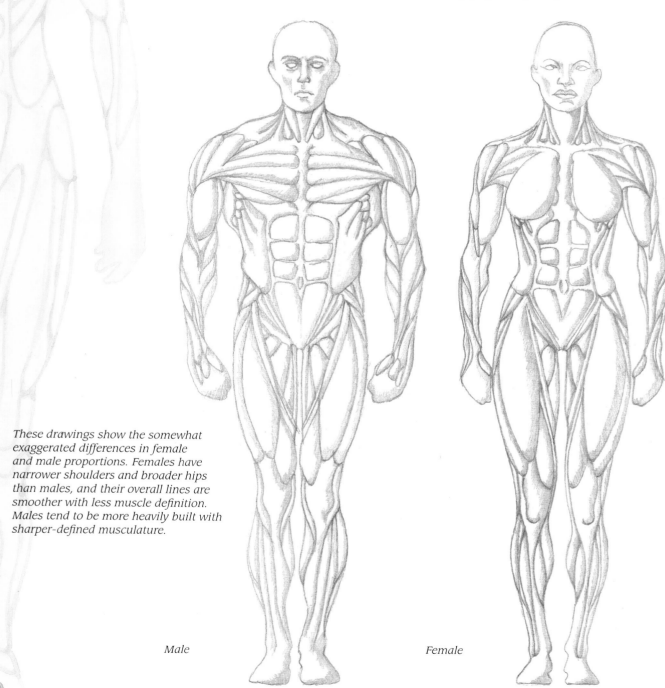

These drawings show the somewhat exaggerated differences in female and male proportions. Females have narrower shoulders and broader hips than males, and their overall lines are smoother with less muscle definition. Males tend to be more heavily built with sharper-defined musculature.

Male

Female

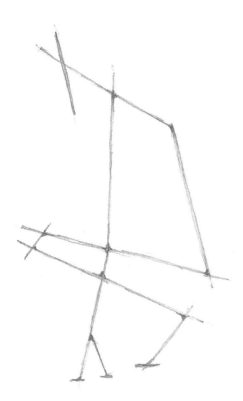

1 Draw a basic 'armature' to show the rough position and angles of your figure.

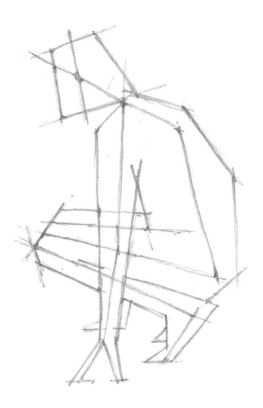

2 Block in the bulk of the figure. Do not worry about details of faces or hands and feet at this stage.

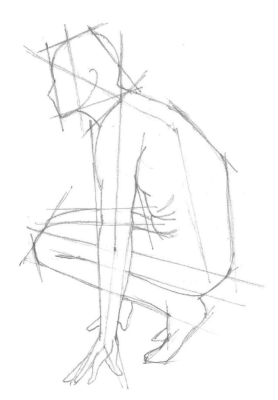

3 Refine your lines, and start to emphasise the details.

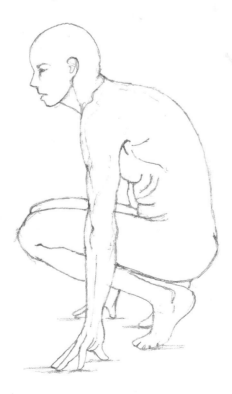

4 Add more detail, and erase unnecessary lines. From here you can add shading, clothes and accessories.

FACES

Drawing faces can appear very difficult. The trick is to keep things simple and slowly build up details – form and shading – after you have got the foundation in place. As with the full figure, look for photographic references or sketch from life – the more you practise, the better you will become.

FRONT VIEW

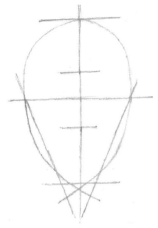 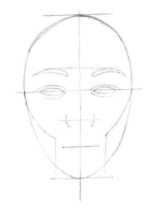 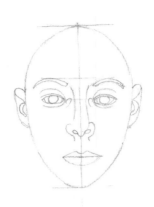 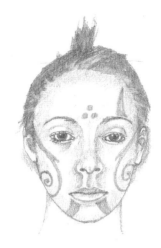

1 Begin with a basic egg shape. Sketch in lines to mark where the eyebrows, eyes, bottom of the nose and the cheekbones might lie.

2 Sketch in the position of the eyes and the mouth.

3 Add ears, and more detail to the nose, mouth and eyes. As a rule the tips of the ears should be approximately in line with the eyebrows, and the lobes in line with the bottom of the nose.

4 Tighten up your lines, and add final details to the eyes and mouth, hair, and any facial markings if you wish.

SIDE VIEW

 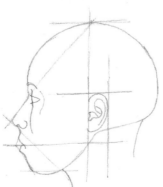 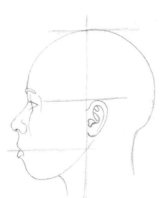

1 Again, begin with a basic egg shape, and mark out the angles of the nose, mouth and chin. Drawing a line from the centre of the top of the head and extending it past the tip of the eyebrow can determine the angle of the nose.

2 Draw in the shape of the mouth and delineate the chin, ear and eye.

3 Soften some of the sharp angles left over from your original construction. Add lips and detail to the eye and ear.

4 Add final details and shading. Again you can add as much decoration or jewellery as you wish.

On this page are some outline drawings showing some expressions which might inspire you and help to get you started. Try making them look older or younger – see what you can achieve.

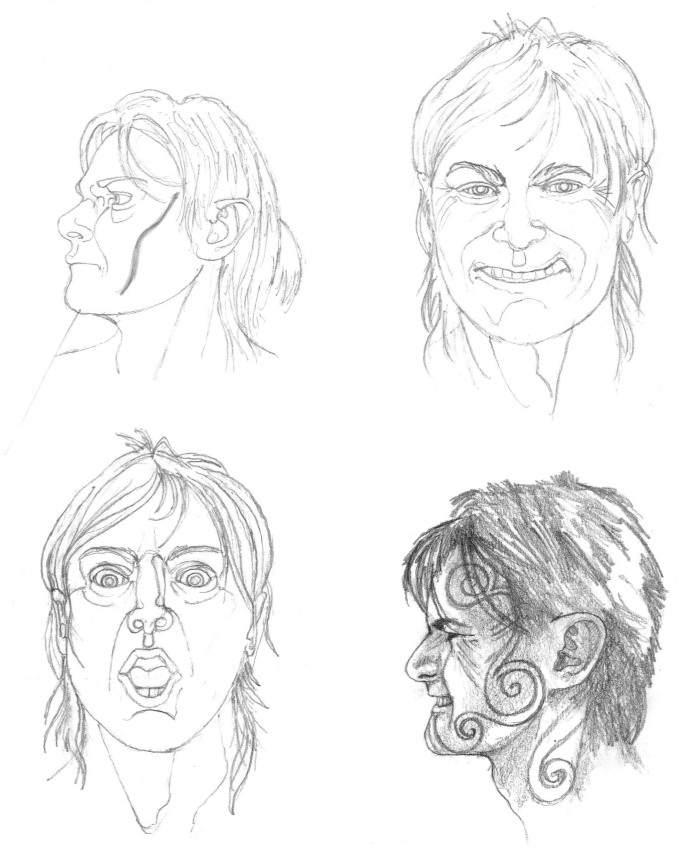

Hands and feet

Hands are as expressive as faces and add to the overall 'feel' of a painting. One way of getting practice at drawing them is to prop a mirror up in front of you and draw your own hands. Looking at photographs and other paintings can be a great source of inspiration.

As always, start simply and build up details later. Some of the most effective hands can be drawn in outline with a single wash over them for the skin tone. Experiment and see what works for you.

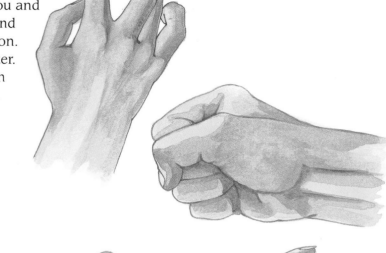

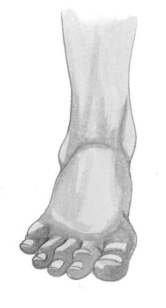

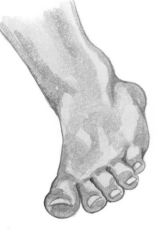

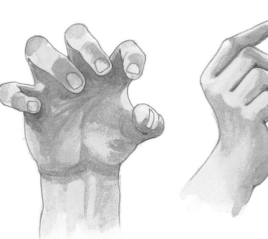

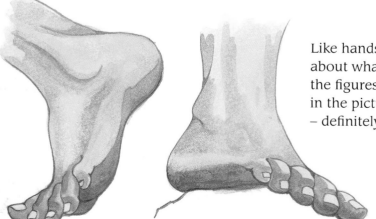

Like hands, feet can convey a lot of information about what is happening in a painting; the stance of the figures and how they are physically 'grounded' in the picture. As before, keep your drawing simple – definitely a case of 'less is more'.

Skin tone

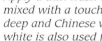

Although the Celts originated in Central Europe, there is no reason to restrict the types of faces that you can use in your paintings. Certainly after the Roman Conquest, Britain was a very cosmopolitan place with African, European and Middle Eastern troops in the garrison. I have given some options on this page, including some distinctly alien looking ladies! There really is no limit to what you can include and if you feel like 'mixing and matching', see what interesting 'Celtic fusions' you can create.

When painting skin tones, keep the first wash fairly pale. It is always easier to build up colour and tone if you start off too light than to try to remove excess pigment. Decide where your light source is and paint the shadows and highlights accordingly. The faces on this page are lit from the left, which throws highlights on to the forehead, nose, cheeks and chin. The areas of shadow are under the chin and neck, along the side of the nose, and around the eyes and ears.

Caucasian Celt
Apply a thin wash of raw sienna mixed with a touch of cadmium red deep and Chinese white; Chinese white is also used for the highlights.

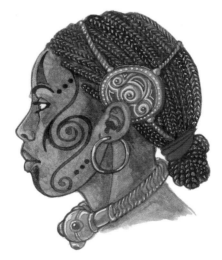

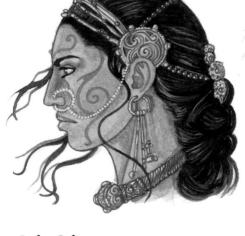

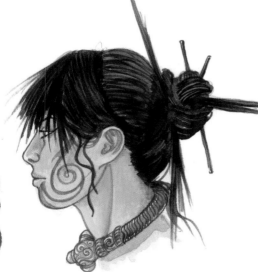

Afro-Celt
Apply a thin wash of burnt umber mixed with raw sienna; use burnt umber for the shadows and Chinese white for the highlights.

Indo-Celt
Use burnt umber for the first wash and strengthen it for the shadows; again, use Chinese white for the highlights.

Nihon-Celt
A wash of raw sienna mixed with cadmium red deep and Chinese white. When this has dried apply a very thin wash of cadmium yellow to give a Japanese tint. Again, use Chinese white for the highlights.

Alien treatments
(Left to right) *Forest Spirit (sap green wash, Hooker's green shadows, Chinese white highlights); Sorceress (Payne's gray wash, darker Payne's gray for shadows, Chinese white highlights); Water Spirit (cobalt blue wash, French ultramarine shadows, Chinese white highlights).*

Hair

On this page and the next are some examples of hairstyles you could possibly use. There is really no limit to the variety you can include in your painting. Look for good pictures of various styles but be careful not to make them too 'modern'.

Using a No. 2 or a No. 3 brush, apply a simple flat wash of your chosen hair colour. On pale, blonde or red hair, use burnt umber or raw sienna to block in shading or mark strands. Use permanent white gouache for the highlights.

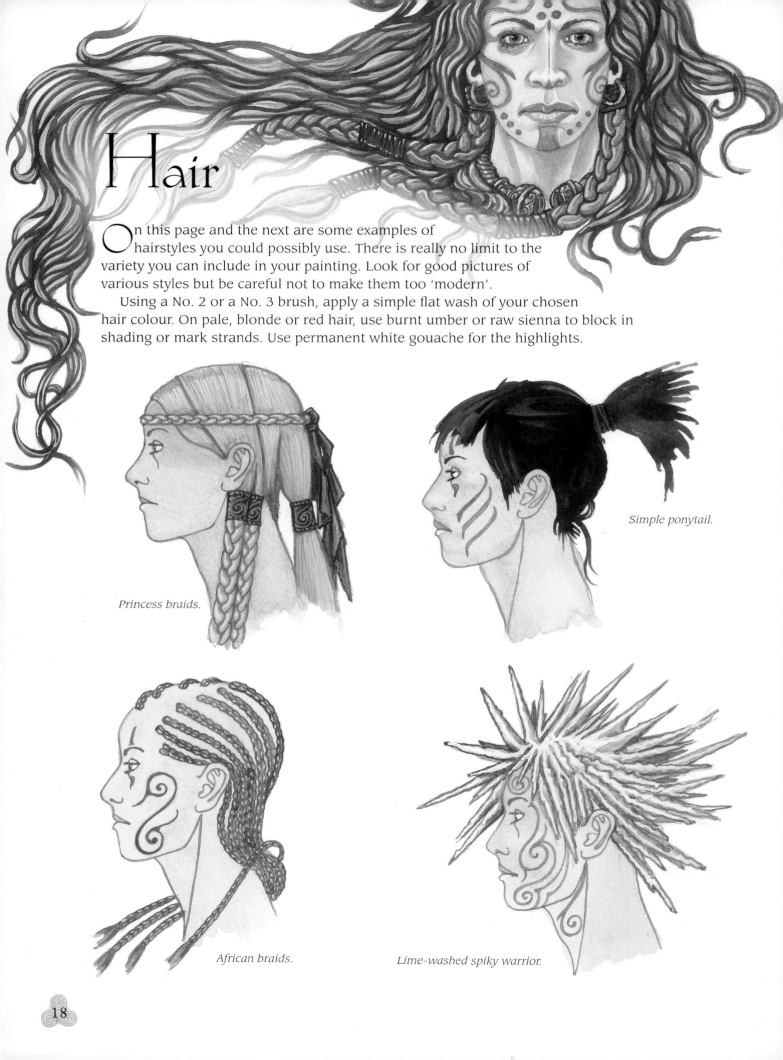

Simple ponytail.

Princess braids.

African braids.

Lime-washed spiky warrior.

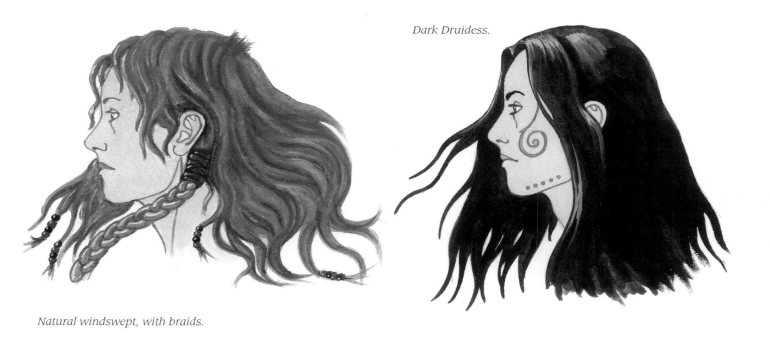

Dark Druidess.

Natural windswept, with braids.

HOW TO PAINT PLAITS

Plaits are the mark of any self-respecting Celt, whether male or female. They look complex but can be drawn relatively simply. Here I have given two methods for constructing plaits.

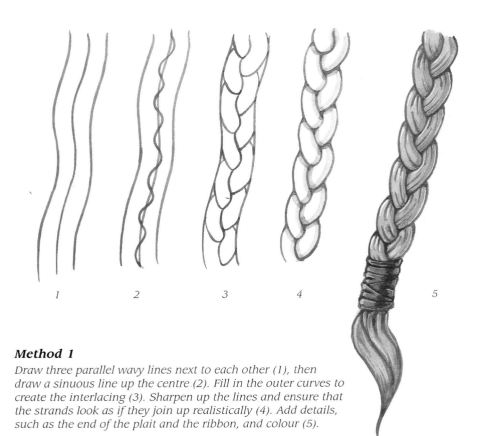

1 *2* *3* *4* *5*

Method 1

Draw three parallel wavy lines next to each other (1), then draw a sinuous line up the centre (2). Fill in the outer curves to create the interlacing (3). Sharpen up the lines and ensure that the strands look as if they join up realistically (4). Add details, such as the end of the plait and the ribbon, and colour (5).

Method 2

To construct a small, tight plait, draw three interweaving lines and then draw on a leaf-like pattern. Simply round off each segment to give the impression of the strands interlacing, and add details as before.

Clothes

When drawing clothing, you can use almost any era for inspiration, from the historical designs of Celtic times, through to a more urban 'Gothic' look. It depends on what atmosphere you wish to create. This page shows a few examples, mainly based upon Renaissance and Medieval costume, which works well for Arthurian subjects. The male figure is more historically correct, but there is nothing to limit your imagination when it comes to stylish Celtic fashion!

Try to make the clothes fit to the contours of the body underneath. Study the way clothes hang in real life – drape a helpful friend or partner in a simple sheet to see where the folds form and the light falls.

Dark Queen or Sorceress, good for Morgan le Fay.

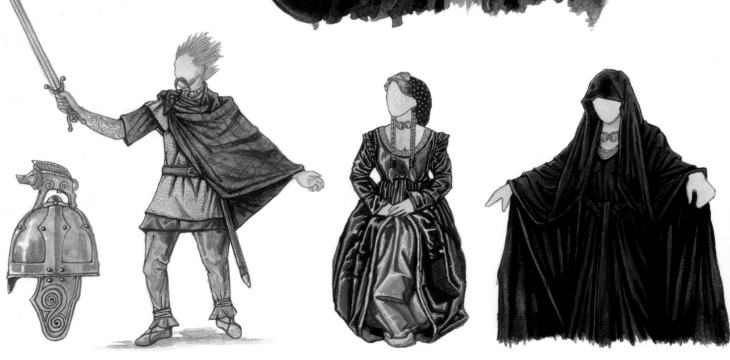

Boar-crested helmet. *Celtic Warrior.* *Celtic Queen or Princess.* *Druidess.*

Ornamentation

The Celts had a love of ornamentation and ostentatious display. This ranged from the golden torcs they wore around their necks to woad body art, and included heavily designed jewellery, weapons and more mundane articles like cauldrons, fire dogs and other utensils. This page shows a few examples that might be a starting point from which you can create your own.

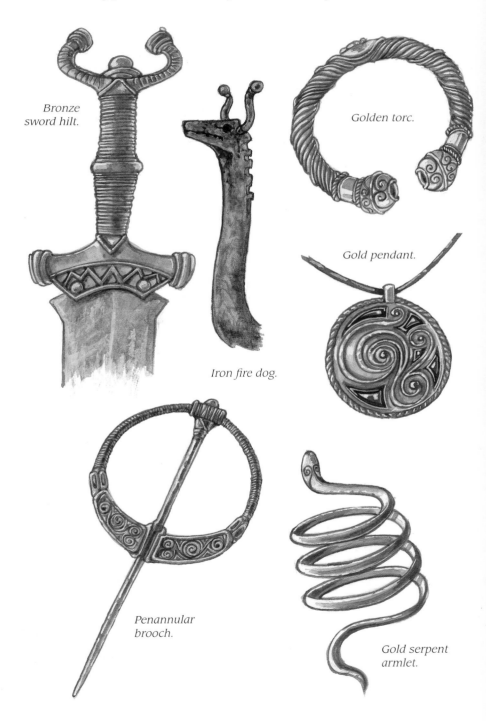

Bronze sword hilt.

Golden torc.

Iron fire dog.

Gold pendant.

Penannular brooch.

Gold serpent armlet.

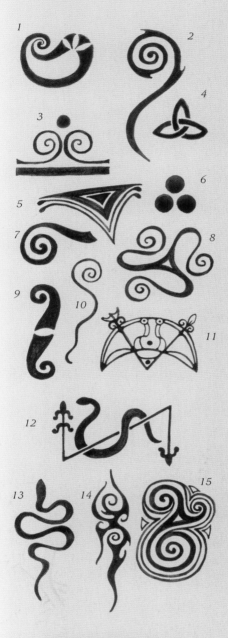

Examples of body art

The symbolic designs above could be used for tattoos. They include single spirals (1, 2, 7, 10); a bar and spiral armband (3); the triquenta (4); a simple triangular design (5); the triple circle of divinity (6); an extended triskele (8); a double spiral (9); a Pictish lunar crescent (11); a serpent and lightning (12); a twisted serpent (13); tribal spirals (14) and a distorted triskele (15).

Symbolism

The symbolic is woven deeply through all Celtic art, myth and legend. Things are never quite what they seem on the surface – people turn into animals, gold into leaves, hills into palaces. A winding line on a page becomes a fabulous beast. All these transformations hint at the shifting nature of reality that the Celts were very aware of, and in tune with.

A cauldron

Magical cauldrons that confer immortality or can provide inexhaustible amounts of food, appear in Celtic myths time and again. They can be seen as prototypes of the Holy Grail as well as symbolising the Otherworld, where all things are broken down and remade.

A snake

Snakes and serpents are often the guardians of hidden treasure or knowledge. Sometimes it is hard to know whether a snake is a goddess or a god, or something else entirely.

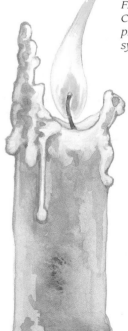

A candle

Fire and flame feature strongly in Celtic myth. The goddess Brigdhe presided over an eternal flame, symbolic of the power of the Sun.

The triquenta

A variation of the triskele (shown below), the triquenta was used much later in Celtic history, especially in Christian contexts.

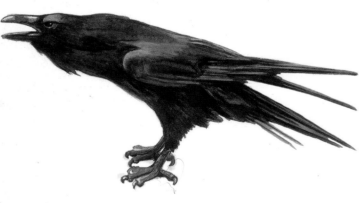

A raven

Possibly the most instantly recognisable Celtic symbol. Morrigan and her sisters took raven form on the battlefield. Often seen as birds of ill omen, they were also revered for their wisdom and intelligence.

The triskele

The number three held special importance in Celtic belief: goddesses and gods would often appear in triplicate, or have three faces; famous characters would have three incarnations – the list is almost endless, like the constant motion of the line in the symbol. In its simplest form, a triangle consisting of three circles, it was the mark of divinity or holiness.

Painting techniques

The next few pages show some of the techniques I use when creating my paintings. Hopefully they will give you a starting point for your own explorations. The bottom line is, always enjoy it!

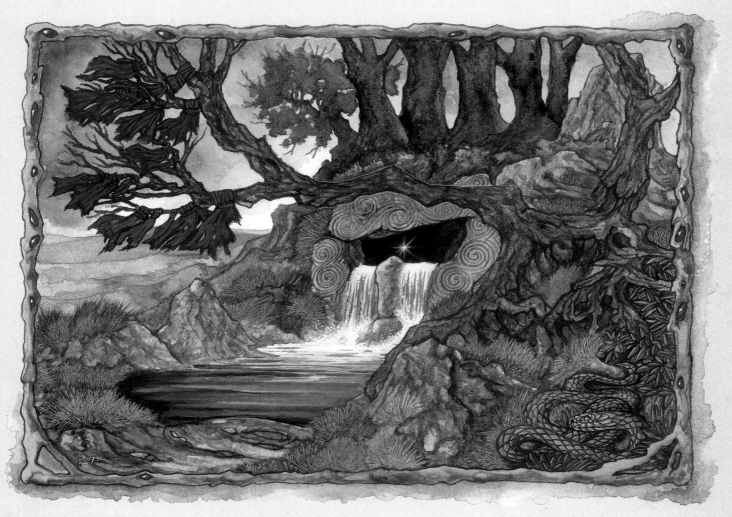

The Sacred Pool

This picture demonstrates all the techniques I have used in this book. The painting shows a sacred pool or spring. Such features were regarded as entrances to the Otherworld, and innumerable strange and wonderful encounters could occur here. The cave from which the water is appearing, the carved rocks, the snake and the small mysterious starburst, indicate that this place is sacred. The palette is muted and harmonious, the major contrast being given by the red 'clooties', tied as offerings to the deity of the pool on the branches of the tree. Clooties were often associated with a prayer or wish. As the colour of the cloth faded, or the cloth disintegrated, so the wish was fulfilled. Similar customs still survive today in the Middle East and in Buddhism.

MASKING OUT

Masking out is a useful technique that I use when painting large areas using wet in wet. The masking fluid provides a protective barrier between the area I am painting and the parts I wish to leave bare, allowing the water and the paint to bleed up to the edge of the bare area but not beyond it. Here, I am masking out the trees and branches so that I can paint the sky area behind them.

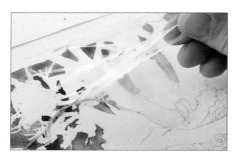

1 Shake the bottle of masking fluid to make sure it is well mixed, then paint on a thick layer just within the outline of the area you wish to mask out. Use an old paintbrush.

2 Allow the masking fluid to dry (this doesn't take very long) and apply paint to the surrounding area. The paint will not adhere to the masking fluid, so it doesn't matter if it accidentally spreads on to it.

3 When the paint is completely dry, the masking fluid can easily be removed by simply pulling it off or rubbing it off with your finger or a putty eraser.

WET ON DRY AND WET IN WET

Wet on dry simply means applying wet paint to a dry background. In this painting, I used wet on dry to lay the base colour on to individual elements before building up the colour and adding detail, for example the cave, rocks, grass, trees, snake and water.

Wet in wet involves applying wet paint to either a wetted background or a layer of paint that is still wet. It allows you to mix different colours on the paper, either randomly to achieve a patchy effect, or in a more controlled way to a create a graduated tone.

Below, I am using both wet on dry and wet in wet to achieve a random, mottled background for the rocks surrounding the cave.

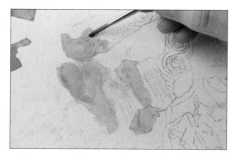

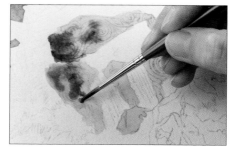

1 Dampen your paintbrush, load it with paint, and apply the paint in a controlled manner to a dry background. Any surplus paint can be removed from your brush by wiping it on kitchen paper. Here, I am applying a base layer of raw sienna to the cave.

2 Add sap green while the raw sienna is still wet, and allow the colours to blend naturally on the paper.

3 Allow the paint to dry, either naturally or with a hairdryer. The advantage of using a hairdryer is that the blast of air can be used to move the paint around on the surface of the paper to create different shapes and patterns.

DRY BRUSHING

This technique involves applying dry paint with a slightly damp brush to a dry background. It is useful for adding detail and texture.

Here I am using dry brushing to build up texture on the rocks surrounding the cave.

DETAILING

Once the base colours have been applied, fine details such as carved patterns, body art, feathers, folds in clothing and so on can be added. I use the tip of a small paintbrush, and apply a fairly wet, deep tone to a dry surface. Black tends to look very dull, so I prefer to use a dark grey or blue, such as Payne's gray or indigo.

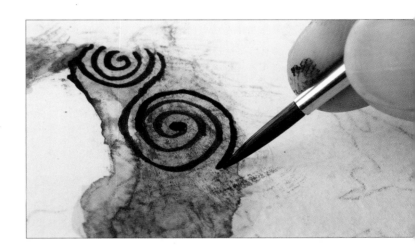

ADDING SHADOWS AND HIGHLIGHTS

When trying to create a feeling of depth, always have in mind where the main source of light is positioned and what surfaces the light strikes within your painting. As a rule of thumb, for general scenes I tend to have light coming from the left. The light will fall on any raised surfaces, causing a shadow to form furthest away from the light source. Observation of lit objects is the key here – noting what happens to light and shadow in your sketchbook will be very useful for future reference.

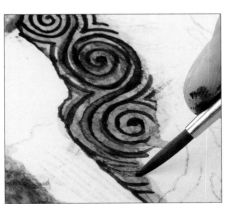

1 First lay on the shadows, using a small brush and a watery, dark mix. Place them on the left-hand sides of the carvings, which are facing away from the light source.

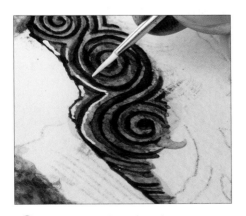

2 For the highlights, apply undiluted white gouache using the tip of a No. 0 brush. Place them where the light is striking the rock, and along the sides of the carvings opposite the shadows.

LIFTING OUT

This technique is a way of lifting paint from your painting to soften its appearance.
In this example, I have used it to give the rock a more weathered appearance.

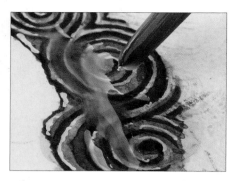

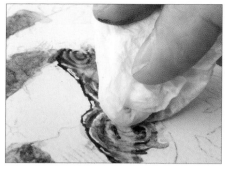

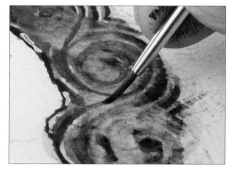

1 Drop water on to the area you wish to lift out using a large paintbrush.

2 Dab off the water using a piece of screwed-up kitchen paper. Some of the colour will have dissolved in the water and be lifted out too.

3 If you accidentally lift out too much colour, simply lightly paint in a little more.

SCRATCHING OUT

Like lifting out, this technique is a way of removing colour from your painting. Here, though, it is scratched out with a sharp point, making it a much more controlled technique suitable for adding details such as the feathers on Morrigan's wings. In this painting, I have used it to create the appearance of blades of grass.

While the paint is still wet, scratch it away to reveal the paper underneath. Use the sharpened end of a paintbrush, or alternatively a barbecue skewer or a cocktail stick. When the paint has dried, lay a light wash over the top of the scratched-out area to tone down the whiteness, depending on the effect you wish to achieve.

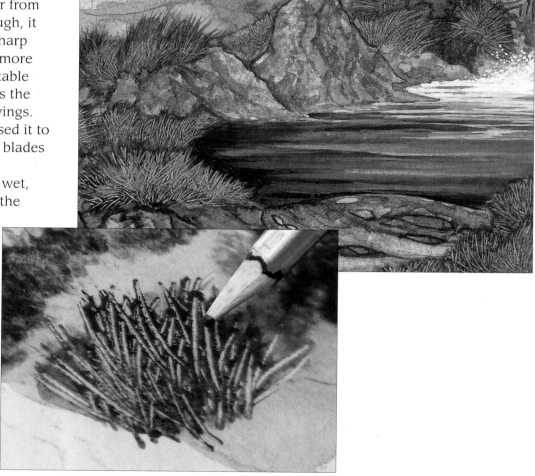

SPATTERING

This is a useful technique for laying a fine spray of paint on your picture. Use it to create a band of stars in a night sky, or sea spray thrown up by stormy waves, as in the Manannan painting on page 47. Here I have used spattering to create spray from the waterfall.

Spattering should be done towards the end of your painting, after covering any areas you don't wish to be 'spattered' with pieces of kitchen paper laid loosely over the top.

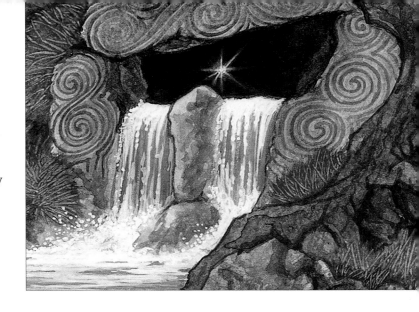

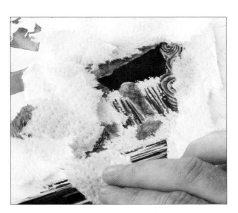

1 Roughly tear up pieces of kitchen paper and lay them gently over the parts of your picture you don't want to spatter.

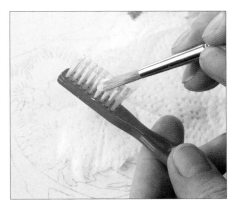

2 Coat the bristles of a toothbrush with paint. I usually use fairly thick, white gouache.

3 Angle the toothbrush downwards, hold it approximately 5cm (2in) from the surface of the paper and rub your finger over the bristles, flicking paint on to your painting.

CREATING A STARBURST

Starbursts add a touch of magic and mystery to your picture. In my painting of Morrigan on page 37, I've placed one at the tip of her finger to suggest power emanating from her body; in this painting I have hinted at hidden magic by putting one at the back of the cave. Use a No. 0 brush and white gouache.

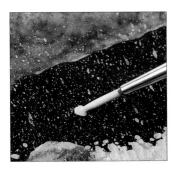

1 Put a dot of paint on the painting to form the centre of the starburst.

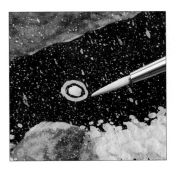

2 Paint a circle around the dot.

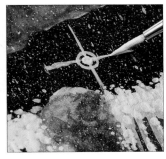

3 Paint in lines radiating from the dot.

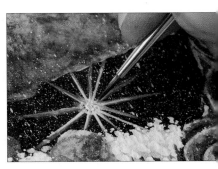

4 Fade the lines out at the tips by stroking them outwards using a clean, damp paintbrush.

Morrigan

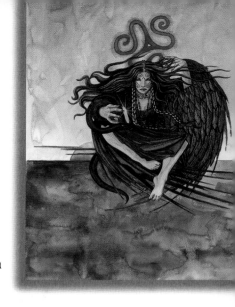

This painting depicts Morrigan, one of a trio of war goddesses from Irish Celtic myth. (Her name means the 'Phantom Queen' or the 'Great Queen'.) She, along with her sisters Badb (the Raven) and Nemhain (Frenzy), rampaged about the battlefield marking out those who were to die. Sometimes these fierce sisters are known as the 'Three Morrigans', indicating that they are a single goddess, another instance of the Celtic idea of triplicity. They were known across the entire Celtic world.

The palette I have used is muted, mainly blue/greys and orange/browns. These colours are complementary, giving a sense of harmony to the picture as well as a hint of menace.

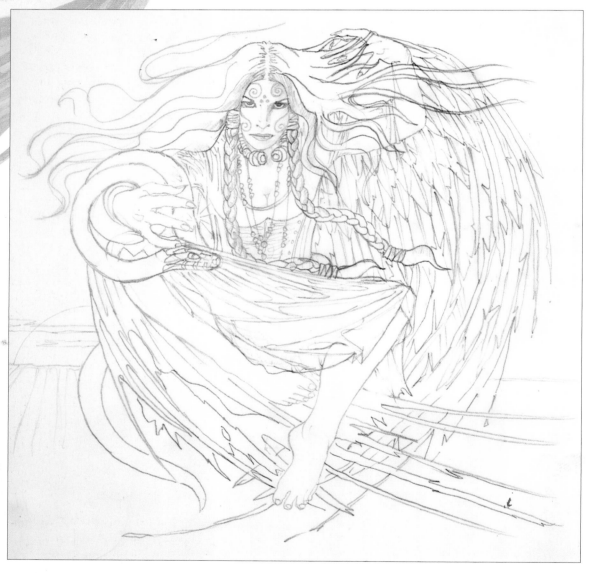

In this picture I have tried to convey the fierceness of the Goddess as well as her unsettling allure. She is shown in the act of transforming from her raven form, and is accompanied by another of her symbolic creatures, the serpent. She could also appear as a wolf or an eel. Hovering over the bleak plain of battle, she reaches out to grasp the souls of dead warriors.

YOU WILL NEED

300gsm (140lb) cold pressed
 NOT paper, 40 × 50cm
 (16 × 20in)
Tracing paper
2H, 3H and F pencils
Adhesive putty or masking tape
Sheet of scrap paper
Scalpel
Putty rubber
Old paintbrush (for applying
 masking fluid)
Old paintbrush with a sharpened
 end (for scratching out)
Nos 0, 2 and 4 round brushes
13mm flat brush
Masking fluid
Kitchen paper
Water pot
Hairdryer
Watercolour paints – burnt
 umber, burnt sienna, cadmium
 red deep, indigo, cobalt
 blue, lamp black, gamboge
 hue, French ultramarine and
 Chinese white
Gouache – permanent white

1 Draw the image on to tracing paper using a 2H pencil. Turn the tracing over, and scribble firmly and evenly over the back with an F pencil. Make sure you cover all the pencil lines of the drawing.

TIP

Refer to pages 23–27 for more detailed explanations of the painting techniques used in this demonstration.

2 Turn the image over again so the right side is facing upwards and centre it over the sheet of watercolour paper. Secure it with adhesive putty or masking tape. Draw carefully over the outline using a 3H pencil, leaning your hand on a scrap sheet of paper to avoid smudging. Press firmly, and maintain a good point on the pencil by sharpening it regularly.

3 Remove the tracing paper, revealing the transferred image underneath. You may need to strengthen the outline by going over it with the 3H pencil.

4 Gently rub over the finished drawing with a putty rubber, removing any soft pencil marks.

CELTIC LORE

Another famous war goddess is Andraste (Victory), who was invoked by Boudicca before she gave battle to the Romans.

5 Add any extra details, if necessary, to improve the composition. These can be either drawn freehand or traced from a reference or drawing. Here I decided to add a triskele.

6 You will begin by painting the sky. To avoid paint spreading to the rest of the drawing, mask it out by applying a layer of masking fluid just within the outline of the figure and below the surface of the ground. Use an old paintbrush. Leave the masking fluid to dry.

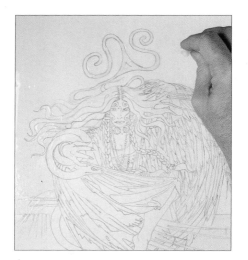

7 Dampen the sky, taking the water right up to the edge of the masking fluid. Drip in the water using a screwed-up piece of kitchen paper and spread it out evenly using a large paintbrush.

TIP

Either paint around the pencil outline using the corner of the brush, or change to a smaller (No. 4 or No. 5) brush.

8 Using a 13mm flat brush, paint in the sky using burnt umber. Keep working the paint so that it lies fairly evenly (with no 'puddles'). Try to achieve a mottled effect, and gradually build up the tone in the top area of the sky so that it becomes progressively lighter towards the horizon. When you have finished painting the sky, dry it with a hairdryer.

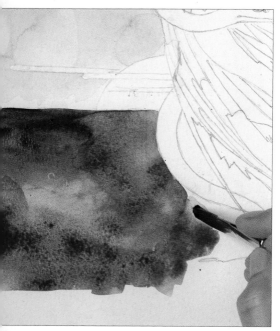

9 Rub off the masking fluid along the surface of the ground and start painting the land using burnt umber. Gradually add burnt sienna, allowing the two colours to mix freely on the paper. Make the area under the sun more red than the rest. As before, try to achieve an overall mottled effect.

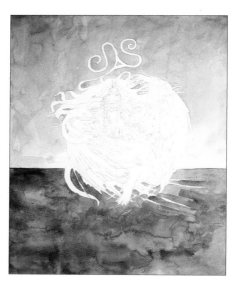

10 Dry with a hairdryer. Strengthen any areas that require more depth of colour, such as the area under the sun, and rub off the rest of the masking fluid.

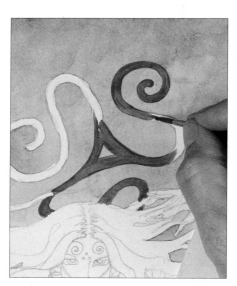

11 Make a mix of cadmium red deep and burnt sienna. Using a No. 4 round brush, paint in the triskele. Apply the paint with a slightly damp brush, but keep the mix fairly dry to give an intense colour.

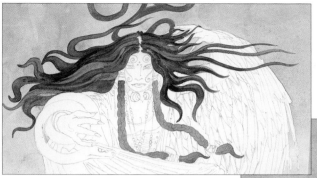

TIP

Don't attempt to apply a completely flat layer of paint to an area – some irregularity of tone will add depth and character to your finished painting.

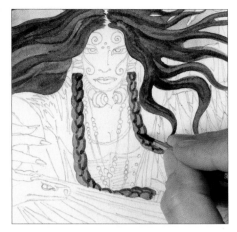

12 Using the same brush, paint over the hair and the plaits using a watery mix of indigo. Paint in the direction in which the hair flows, and separate the locks by varying the intensity of the blue.

13 Outline the sections of the plaits using a deeper mix of indigo to give them form. Use a small (No. 0) paintbrush.

TIP

Your finished painting will appear more cohesive if you use the same mixes in different areas. In this case, the red of the triskele is reflected in the colour of the braids.

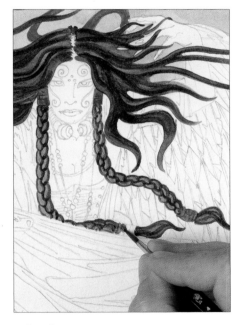

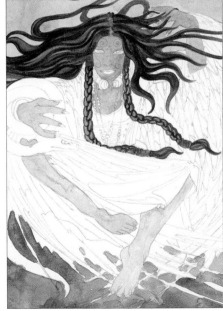

14 Similarly, strengthen the edges of the locks of hair.

15 Paint the braids around the plaits using the same mix of cadmium red deep and burnt sienna as you used for the triskele. Again, add detail using a darker mix.

TIP

A little permanent white gouache added to a colour will make it more opaque.

16 For the skin tone, mix together some permanent white gouache with indigo (the white makes the indigo more opaque). Using a No. 0 brush, apply a thin layer of paint to the face, chest and limbs so as not to obscure the patterns underneath.

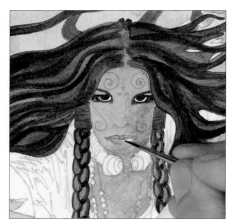

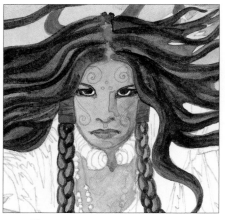

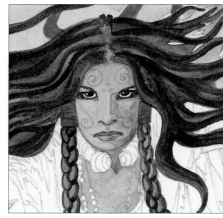

17 Using indigo and the No. 0 brush, paint the details on the face. Start with the eyebrows and eye sockets, then using a darker tone, paint in the irises. Try to make the eyes as even as possible. Next, paint in the lips. Use a lighter mix, and make the top lip slightly darker than the lower lip. Do not paint in the nose at this stage.

18 Apply shadows to the shaded parts of the face, the neck and the area around the base of the face to define the jawline. Suggest the shape of the nose by placing shadows down the right-hand side and underneath it.

19 Add gentle highlights to the lighter parts of the face, such as the ridge and tip of the nose and the cheekbones, using a watery mix of permanent white gouache. Using a stronger mix, complete the eyes by painting in the whites and placing a 'glint' of light in each one.

TIP

Be guided by the natural flow of the paint over the paper; the subtle variations in tone that result are far more appealing than the flat, even tone obtained if the paint has been over-controlled.

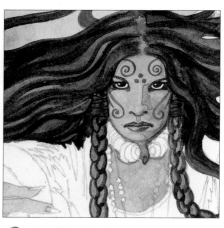

20 Paint in the body art using a watery mix of cobalt blue and a hint of indigo.

CELTIC LORE

The Celts' love of decoration extended to body art. They used woad, that gives an indigo blue dye, to paint designs on their bodies. Many warriors went into battle naked except for their tattoos!

21 For the dress, use indigo applied with a No. 4 brush. Use a fairly watery mix, and paint in sweeping strokes, in the direction of the folds of the dress. Once the first layer has dried, apply a second layer to build up the colour.

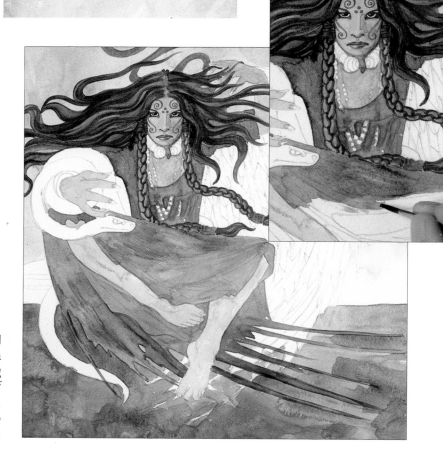

22 Use a No. 2 brush and a watery mix of lamp black to create the folds and dark shadows. Apply it around the lower part and sides of the bodice, beneath the legs and within the folds of the fabric.

23 Strengthen the colour of the dress by applying another layer of indigo, then deepen the shadows and folds with another layer of lamp black.

24 Go back to using the No. 4 round brush and apply a light wash of lamp black over the wing, dropping in some burnt umber as you work to reflect the colour of the background. Allow the two colours to mix randomly on the paper to create a mottled effect.

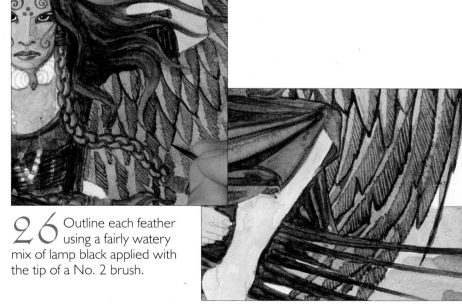

25 Working on two or three feathers at a time, lay a fairly dry mix of indigo over the right-hand side of each feather, wait a few seconds, then scratch out the veins using the sharpened end of an old paintbrush.

26 Outline each feather using a fairly watery mix of lamp black applied with the tip of a No. 2 brush.

27 Add shadows in the corners of the lower feathers to create a three-dimensional effect.

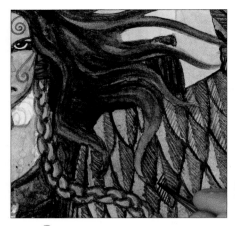

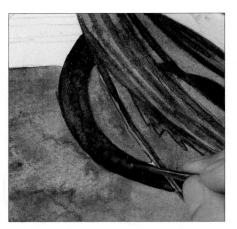

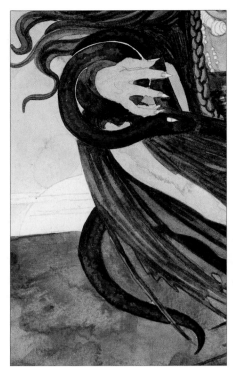

28 Add veins to the left-hand sides of the feathers, and strengthen the outlines if necessary.

29 Begin to paint the snake. Lay in a first wash of lamp black, then while it is still wet drop in a line of cadmium red deep down the centre. The red paint needs to be quite thick so that it stands out vividly against the black.

30 Leave the eye blank, and retain a thin white line between the coils to delineate them.

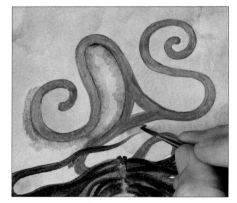

31 Paint in the sun using a fairly intense mix of gamboge hue applied with a No. 4 brush. While it is still wet, drop in some cadmium red deep along the bottom, and drag the colour upwards to blend it in gradually with the yellow.

32 Accentuate the triskele by applying a little burnt umber around it using a No. 4 brush. Dampen the brush to blend the edges of the paint into the background.

CELTIC LORE

The torcs that many Celts wore around their necks were made of gold or twisted gold wire and were a symbol of high status. Gods, goddesses and nobles are always depicted wearing them.

33 Using raw sienna and a No. 0 brush, place a light wash of colour over the torc around the figure's neck. Allow the paint to dry, then add shading using a watery mix of burnt umber. Allow the paint to dry again, then use undiluted burnt umber to outline the coils.

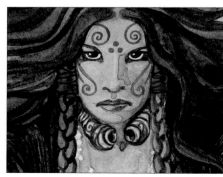

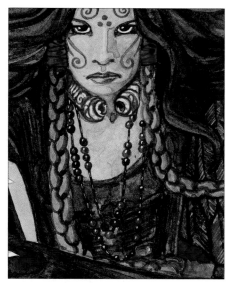

34 For the necklace, use a No. 0 brush to paint in the cord in lamp black. Paint the beads by dropping in very dry mixes of cadmium red deep, cobalt blue and French ultramarine. Sharpen the edges of the beads using burnt umber. Finally, place a tiny white highlight on each bead and on parts of the cord using permanent white gouache.

35 Outline the folds and cross-overs on the braids using lamp black and the tip of the No. 0 brush. Add shading and highlights using indigo and permanent white gouache. Using the same colours, sharpen the outlines on the plaits and add highlights to the plaits and hair.

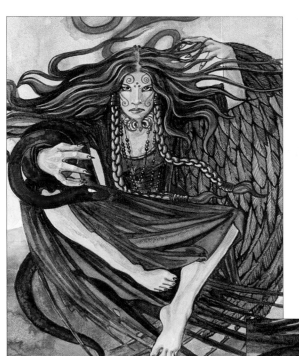

36 Outline the hands in lamp black using the same brush, then change to a No. 2 brush and paint in the shadows using a light wash of indigo. Paint in the fingernails using a dark indigo mix, and use the same mix to darken the deep shadows in between the fingers. At the same time, tone down the white spaces left between the coils of the snake. Finally, add highlights to the nails, knuckles and bones of the hand using permanent white gouache. Complete the feet in the same way, and add shadows and highlights to the arms and legs.

37 Use burnt umber to paint in the clouds drifting across the setting sun and to strengthen the horizon.

38 Complete the snake's face: outline the features in lamp black, painting in the eye using gamboge hue. Put in a white highlight over the eye, the nostril and along the bottom of the mouth. Complete the painting by adding a starburst at the tip of Morrigan's finger (see page 27).

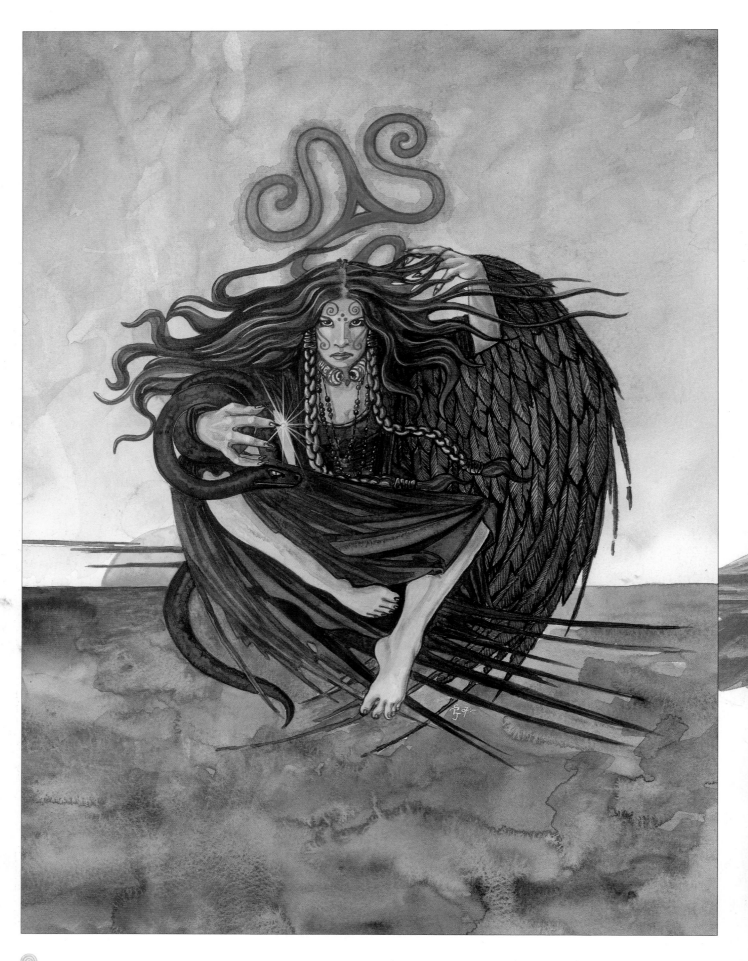

Morrigan

Based upon the circle, this composition has a compact power. The encircling wing and the shreds of Morrigan's dress flowing in the opposite direction frame her face. The dynamic pose of her body gives the impression that she is hovering or leaping towards you. You take on the role of the warrior, facing your last moments! The colours have been kept deliberately muted to emphasise the blood red and gold elements. Morrigan is certainly no goddess to be trifled with!

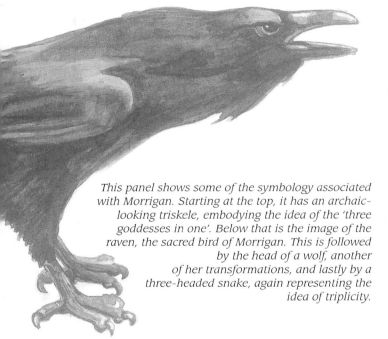

This panel shows some of the symbology associated with Morrigan. Starting at the top, it has an archaic-looking triskele, embodying the idea of the 'three goddesses in one'. Below that is the image of the raven, the sacred bird of Morrigan. This is followed by the head of a wolf, another of her transformations, and lastly by a three-headed snake, again representing the idea of triplicity.

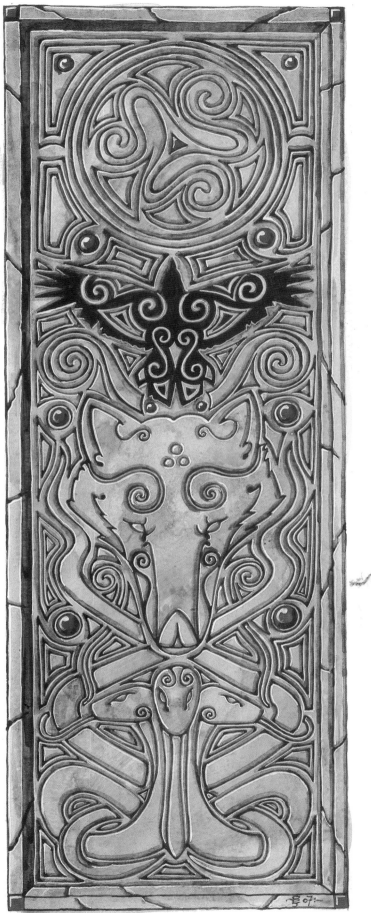

Manannan

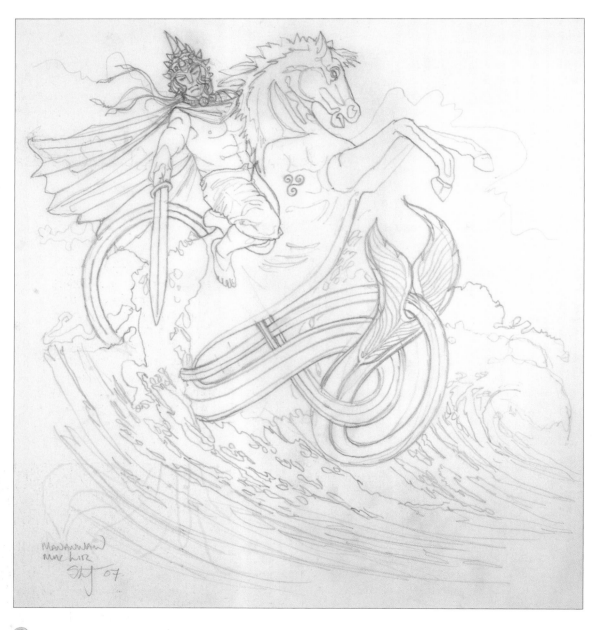

This demonstration is a painting of the Celtic sea god Manannan Mac Lir. His name means 'Son of the Sea' and he was the god of sailors and merchants. His favourite home was the Isle of Man, which he gave his name to. Eventually Manannan became King of the Gods and was known for providing the 'Feast of Age' at which those who ate never grew old. This was achieved by his wondrous pigs, which resurrected themselves as soon as they were eaten.

But he is far more famous for being the 'Rider of the Crested Sea' upon his horse, 'Splendid Mane'. As such he was seen very much as a guide of souls across the Sea of Death to the beautiful Otherworld. It is interesting that we still refer to breaking waves as 'white horses', perhaps in his memory. It is Manannan in this last guise that I have tried to capture in my painting.

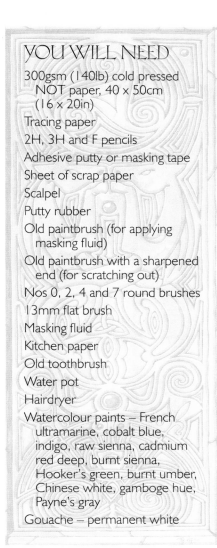

YOU WILL NEED

300gsm (140lb) cold pressed
 NOT paper, 40 x 50cm
 (16 x 20in)
Tracing paper
2H, 3H and F pencils
Adhesive putty or masking tape
Sheet of scrap paper
Scalpel
Putty rubber
Old paintbrush (for applying
 masking fluid)
Old paintbrush with a sharpened
 end (for scratching out)
Nos 0, 2, 4 and 7 round brushes
13mm flat brush
Masking fluid
Kitchen paper
Old toothbrush
Water pot
Hairdryer
Watercolour paints – French
 ultramarine, cobalt blue,
 indigo, raw sienna, cadmium
 red deep, burnt sienna,
 Hooker's green, burnt umber,
 Chinese white, gamboge hue,
 Payne's gray
Gouache – permanent white

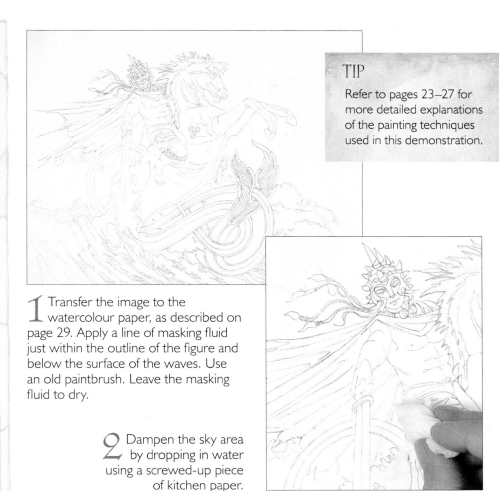

TIP

Refer to pages 23–27 for
more detailed explanations
of the painting techniques
used in this demonstration.

1 Transfer the image to the
 watercolour paper, as described on
page 29. Apply a line of masking fluid
just within the outline of the figure and
below the surface of the waves. Use
an old paintbrush. Leave the masking
fluid to dry.

2 Dampen the sky area
 by dropping in water
using a screwed-up piece
 of kitchen paper.

TIP

Apply paint randomly to large
areas to achieve a patchy effect,
but without any dry areas or
'puddles'. Allow the paint to flow
freely over the surface of the
paper and work with the patterns
it creates rather than against them.
When drying the paint, use the
hairdryer to 'move' paint around
to create interesting patterns
and effects.

3 Using a 13mm flat brush,
 paint in a damp mix of French
ultramarine. Gradually build up the
colour to the desired depth, making
the sky darker towards the top and
lighter at the horizon.

4 Dry the area with a hairdryer,
 then drop in patches of fairly wet
cobalt blue.

5 Dry the second layer in the same way, soften any hard
 edges with a damp brush, and 'pull' the paint into any
bare areas. Drop some indigo into the top area of the sky
and blend it in at the edges to create a stormy effect.

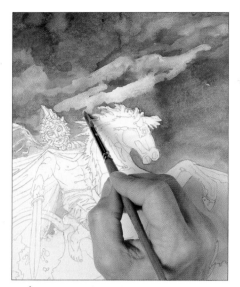

6 Using a No. 7 round brush, drag a watery mix of permanent white gouache across the sky to represent a trail of stars. Blend it into the background using a damp brush and soften any hard edges.

7 Put dots of white to represent stars all over the sky, but mainly in the white area, using the tip of a No. 2 brush and permanent white gouache.

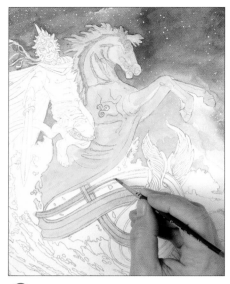

8 Rub off the masking fluid and put a base wash of raw sienna over the body of the horse. Use a No. 4 brush. Build up the darker areas with more layers of the same wash.

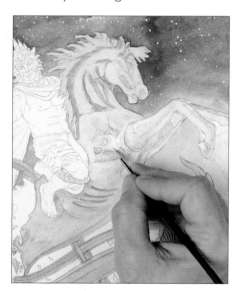

9 Lighten up the base colour where the light strikes the horse using a thin wash of permanent white gouache. Do not add any white to the tail.

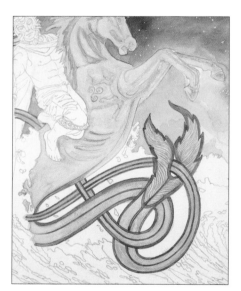

10 Make a mix of cadmium red deep and burnt sienna and outline the horse's tail in red using a No. 2 brush. Extend the red underneath the horse's belly and fade it out into the raw sienna. Also paint a red stripe down the centre of the tail.

TIP

Build up colour in several thin layers rather than as a single thick layer – it is easier to put more colour on than to take it away.

11 Paint in the tail fin using a fairly dense mix of Hooker's green. While the paint is still wet, scratch out the veins using the sharpened end of an old paintbrush.

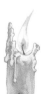

CELTIC LORE

Manannan had many wondrous possessions, apart from Splendid Mane who could gallop faster than the spring wind over land and sea. His sword was called 'Retaliator' and it never failed to slay. He also had a boat called 'Wave Sweeper' which moved and navigated itself across the ocean.

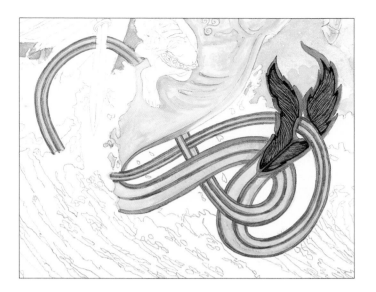

12 Allow to dry, then outline the green areas in indigo using the tip of a No. 2 brush. Darken the corners and soften the green with a damp brush, blending it into the white veins. Add a thin stripe of burnt umber under the top and middle red lines for a three-dimensional effect.

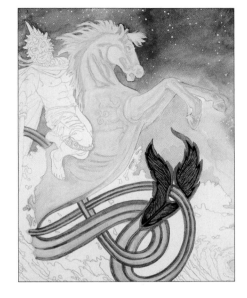

CELTIC LORE

Manannan's magical cloak made anyone who wore it invisible.

13 Add permanent white gouache to the horse's mane, and strengthen the white highlights on its body. Use a No. 4 brush.

14 Make a mix of burnt sienna and cadmium red deep, and cover Manannan's cloak in a wash of red. Use a No. 4 brush, and lay the paint on in the direction of the folds of the cloak. Vary the tone slightly for a more interesting finish.

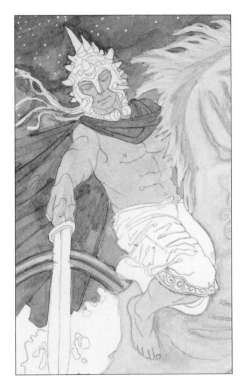

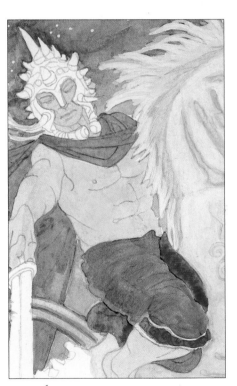

TIP

Review your painting constantly, strengthening colours and outlines where necessary as it develops.

15 For the skin tone, mix together raw sienna, Chinese white and cadmium red deep and apply it to the face, arms, legs and body.

16 Paint the trousers using a wash of Hooker's green, and add the same red as you used for the cloak to the central part of the decorative edging around the hem. For the saddle, use burnt sienna.

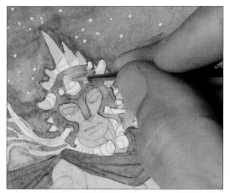

17 For the helmet, paint the main part using Hooker's green and a little cobalt blue, allowing the two colours to blend on the paper. Apply them with a No. 2 brush. Drop in a little gamboge hue and a touch of permanent white gouache while the paint is still wet. For the horns, mix a little raw sienna with permanent white gouache and apply with a No. 0 brush.

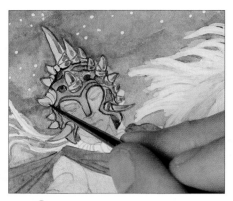

18 The jewels are cadmium red deep and French ultramarine, and the patterns on the helmet are drawn on in indigo using the tip of the brush. Add shadows by placing a little Indigo down the right-hand side of the helmet, and some burnt umber down the right-hand sides and undersides of the horns.

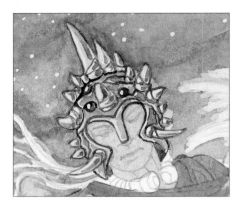

19 Add sharp highlights to the horns and jewels, and paler highlights to the main body of the helmet, using permanent white gouache.

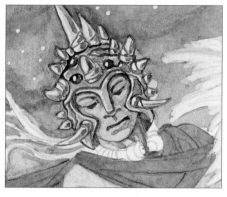

20 Paint in the details on the face using burnt umber applied with a No. 0 brush. Add highlights using permanent white gouache.

21 Paint the tassels using Hooker's green and a No. 0 brush, then paint the braids using cadmium red deep. Add highlights using permanent white gouache, and blend them in with a damp brush. Draw in the detail on the braids and outline the tassels using indigo, then finally add sharp white highlights to the braids and along the edges of the tassels.

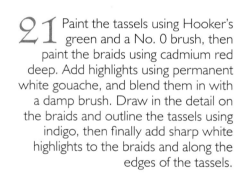

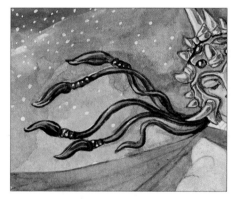

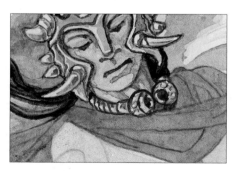

22 Lay a wash of raw sienna over the torc around the figure's neck, then define the coils and outline them in burnt umber. Add permanent white gouache highlights.

23 Using a No. 2 brush, outline the cloak and paint in the shadows created by the folds using indigo. Blend in the blue using a damp brush. Strengthen the colours if necessary.

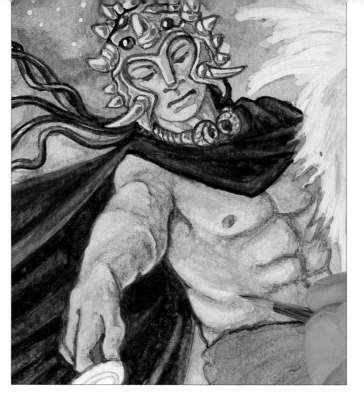

24 Define the contours of the body using burnt umber, then add highlights using permanent white gouache blended in with a damp brush.

25 Paint the leg in the same way.

26 Using raw sienna, paint the hilt of the sword. Use burnt umber for the outline and detailing. For the blade, apply a very thin wash of Payne's gray with a No. 4 brush. Paint on the groove down the centre and the shadow around the base of the hilt using a slightly darker mix of the same colour and a No. 2 brush. Soften the line out on the left-hand side of the groove and add a highlight along the other side using permanent white gouache. Also add highlights to the left-hand edge of the sword and its tip. Finally, drag some highlights diagonally across the blade where the light catches it, and strengthen the outline if necessary.

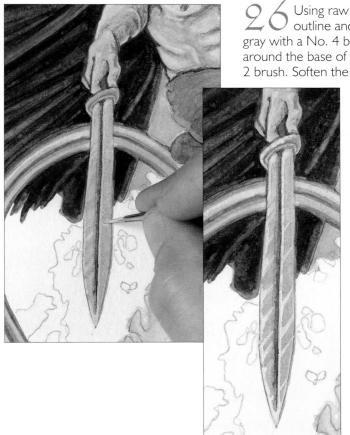

TIP

Don't be too concerned about the order in which you work – there are no hard-and-fast rules. Move instinctively from one part of the painting to another, and avoid focusing too heavily on one particular area.

27 Strengthen the outline around the trousers and add the folds and shadows using indigo applied with a No. 2 brush. For the highlights, use permanent white gouache. Change to a No. 0 brush and paint in the border and patterns on the edging.

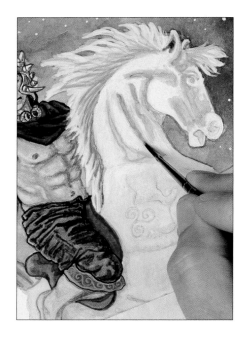

TIP

Adding a layer of blue paint over a base of yellow produces a pearlescent green tone that is reminiscent of the sea.

28 Complete the saddle by adding some shading using burnt umber and a No. 2 brush. Apply soft shadows to define the horse's mane, and the features and contours on its head and neck. Use a thin wash of indigo, softening out the strokes using a damp brush.

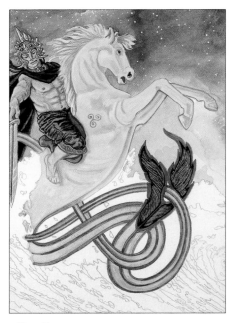

29 Apply shadows to the rest of the horse's body and paint in the eye, mouth and nostril using the same colour. Strengthen the brightest highlights with permanent white gouache, and place a tiny 'glint' in the eye. Complete the horse by adding the triskele using a watery mix of cobalt blue, and strengthening the outline with a thin line of indigo.

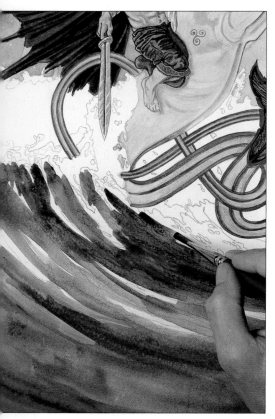

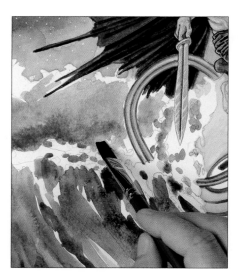

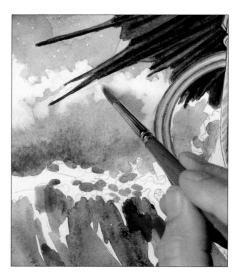

30 Using a 13mm flat brush, start to paint the sea by layering in a watery mix of Hooker's green. Leave the crest of the wave bare to begin with. Every so often drop in some cobalt blue and allow the two colours to blend naturally on the paper. Work in sweeping brush strokes following the shape of the wave.

31 Dab some green and blue paint into the crest of the wave, making the top part mainly green and the lower part predominantly blue.

32 Using a No. 7 round brush, add some permanent white gouache to the top of the wave, allowing it to bleed into the green paint below.

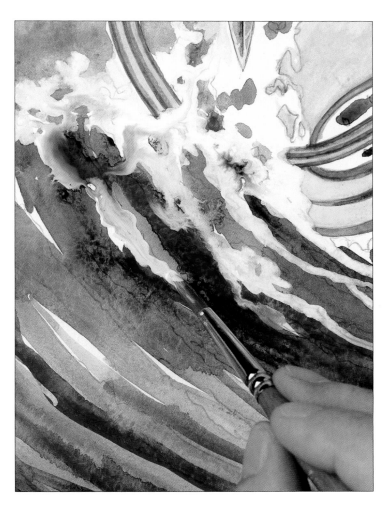

TIP

As you lay in the white gouache, twist the brush to create wavy, irregular lines. This mimics the form and movement of the water and makes it look more realistic.

CELTIC LORE

The coat of arms of the Isle of Man shows three legs conjoined. This refers to a legend that says when Manannan was king of the island he had three legs, upon which he used to travel about at great speed. It is also a reference to the triskele, which is Manannan's symbol.

33 Continue adding white gouache, pulling the paint down into the main body of the wave and fading it out at its base. Follow the shape of the wave as before, and twist the brush as you work to create a sense of movement.

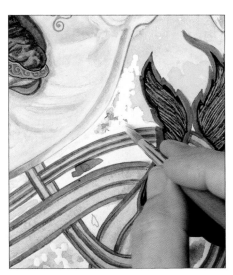

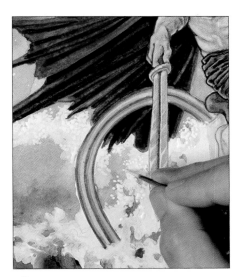

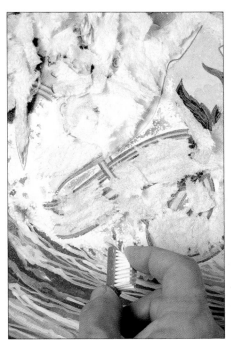

34 Blend in the white paint with the green and blue in some places. Change to a No. 2 brush for working on smaller areas.

35 Dry the paint with a hairdryer and add tiny dots of white along the leading edge of the wave using the tip of the No. 2 brush.

36 Use the spattering technique (see page 27) to lay on a fine mist of permanent white gouache to represent sea spray. Protect the main parts of the rest of the painting using torn-up pieces of kitchen paper.

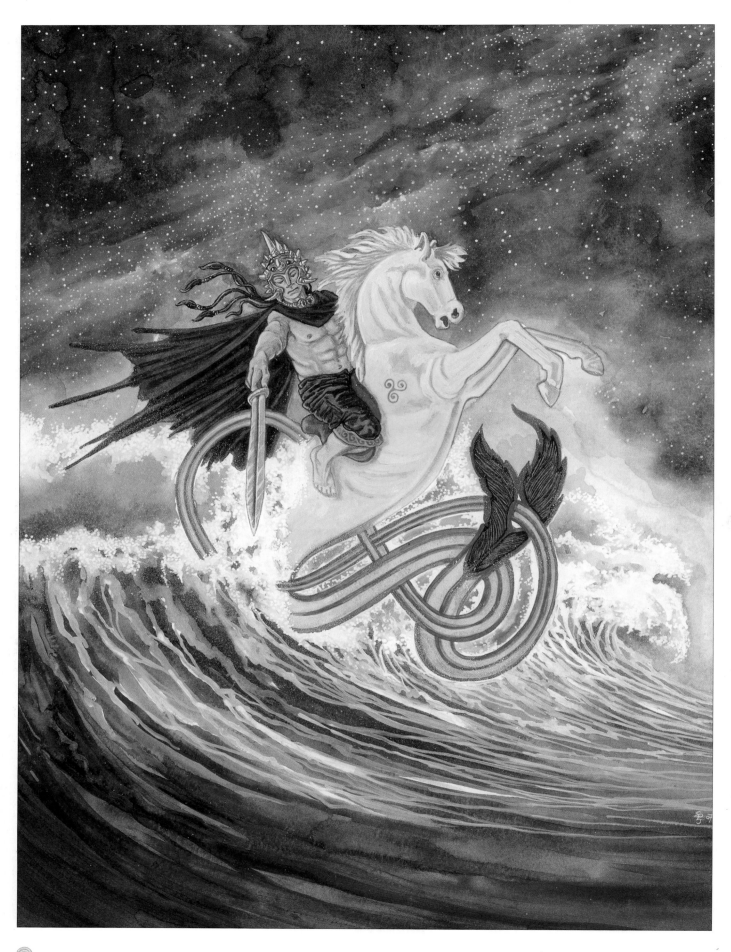

Manannan

The picture shows Manannan riding Splendid Mane, leaping through the breaking waves. I thought it might be interesting to transform Splendid Mane into a sea horse by merging his hindquarters into a knotwork fish tail. The pose of the horse and the waves gives a forward dynamic to the piece, and the colours were chosen to reflect the shades of the sea, set off by the royal red of Manannan's cloak.

This panel shows some of the symbols associated with Manannan. The triskele is his very own symbol and also that of his home, the Isle of Man. The sea horses refer to Splendid Mane as well as Manannan's rulership of the White Horses of the Waves. The final symbol is from a Pictish carved stone; the lunar crescent alludes to the power of the tides and the V-shaped rod could be a compass for souls to guide them to the Otherworld.

Index